An Abecedarium

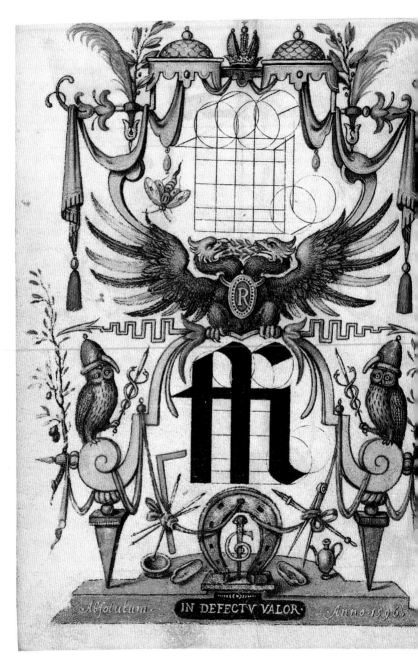

Absolutum. IN DEFECTV VALOR. Anno 1596.

An Abecedarium

ILLUMINATED ALPHABETS
FROM THE COURT OF
THE EMPEROR RUDOLF II

Lee Hendrix and
Thea Vignau-Wilberg

THE J. PAUL GETTY MUSEUM
LOS ANGELES

The illustrations in this book have been selected from
Mira calligraphiae monumenta,
first published by the J. Paul Getty Museum
and Thames and Hudson, Ltd. in 1992.
The texts have been adapted from
the same volume.

Christopher Hudson, *Publisher*
Mark Greenberg, *Managing Editor*

© 1997 THE J. PAUL GETTY MUSEUM
Suite 1000
1200 Getty Center Drive
Los Angeles, California 90049–1687

On the front cover: Folio 130
On the frontispiece: Folio 151v

Printed and bound in Singapore by C.S. Graphics

Introduction

T HE ALPHABETS in this book were commissioned by the
Habsburg Holy Roman Emperor, Rudolf II, from the
last of Europe's great illuminators, Joris Hoefnagel
(1542–?1601), at some point during the final decade of the
sixteenth century. Though a poor politician, Rudolf was a
man of great learning who patronized both artists and early
scientific thinkers such as Johann Kepler (whose Rudolfine
Tables were named in his honor) and Tycho Brahe. Hoefnagel
is an artist of genius whose work represents the last great
flowering of the manuscript illuminator's art in the West and
at the same time points directly to the emergence of the
essentially new genre of floral still life painting in the early
seventeenth century.

The magnificent illuminations in this volume are taken
from a larger manuscript, now housed in the J. Paul Getty
Museum, called the *Mira calligraphiae monumenta,* or the *Model
Book of Calligraphy*. The alphabets are bound into the back of
the volume, beginning on folio 130 (someone, though probably
not Hoefnagel himself, has numbered the folios in red in the
top right-hand corner of each page – A is thus '130', B '131',
etc.). There are two alphabets here, the first of Roman
majuscules (upper-case or capital letters) and the second of
Gothic minuscules (lower-case letters). The illuminations
of the majuscules are elevated in tone and conform to an
abecedarium, that is, a collection of verses beginning with
different letters running alphabetically from A to Z. Each is
inscribed at its base with a verse from the Psalms that begins

with (or includes near the beginning) the letter in question and is composed of imagery illustrating the biblical text. Much of this imagery refers symbolically to the patron, Emperor Rudolf II. The illuminations of the minuscules stand in marked contrast, being humorous and featuring natural specimens, hybrid creatures and a series of fanciful masks. (The imagery is described and explained in more detail in the section of notes beginning on p. 49.)

A characteristic creation of Renaissance artists and literati, these constructed alphabets, and particularly that of the Roman majuscules, express the then widespread belief in a universe governed by principles of measure and proportion revealed through the correspondence of microcosm to macrocosm. Hoefnagel's illuminations imbue this association with specific religious and political content by linking the alphabet to the word of God and thence to his representative on earth, the Holy Roman Emperor.

THE
ROMAN MAJUSCULE
ALPHABET

Hoefnagel's organization of the Roman majuscules conforms to an abecedarium — a collection of verses that begin with different letters in alphabetical order from A to Z. The accompanying imagery, which glorifies God or Emperor Rudolf II, was carefully selected by the artist to enhance the symbolic meaning of each of the folios. With the exception of the letter 'A', Hoefnagel chose verses from the Psalms exclusively. The imagery on each folio is based on the meaning of the initial word in the verse, the significance of several words, or the message conveyed by the verse as a whole. Hoefnagel's figural imagery is balanced and symmetrical, uniformly filling the top, bottom and side margins as well as any empty space in the middle.

Captions to the plates on p. 49 ff.

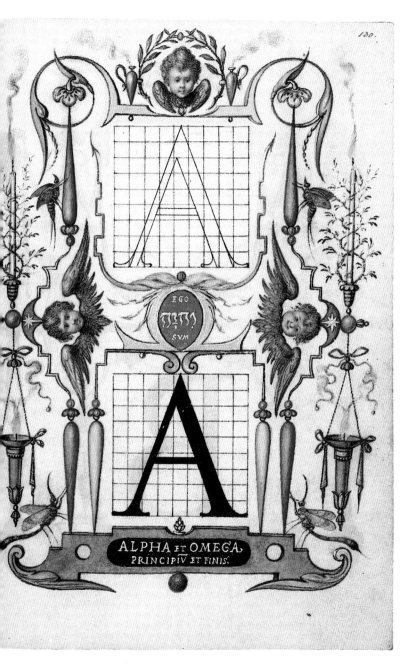

EGO אהיה SVM

ALPHA ET OMEGA,
PRINCIPIV ET FINIS.

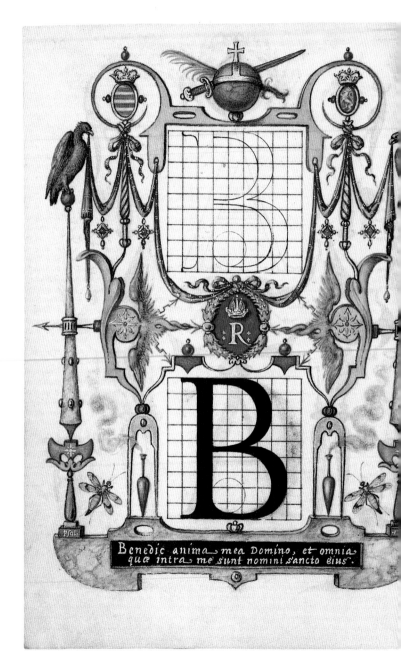

Benedic anima mea Domino, et omnia
quæ intra me sunt nomini sancto eius.

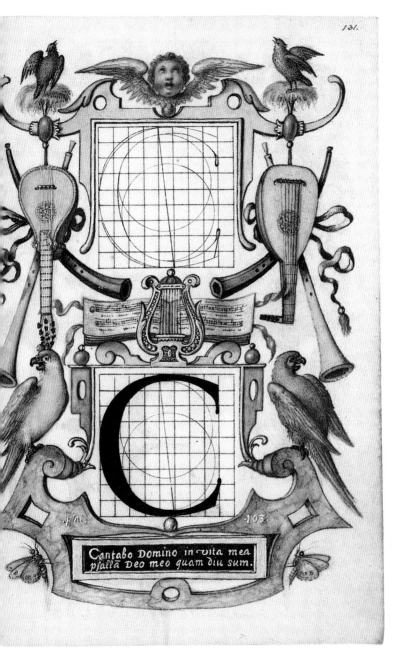

103.

Cantabo Domino in vita mea
psallã Deo meo quam diu sum.

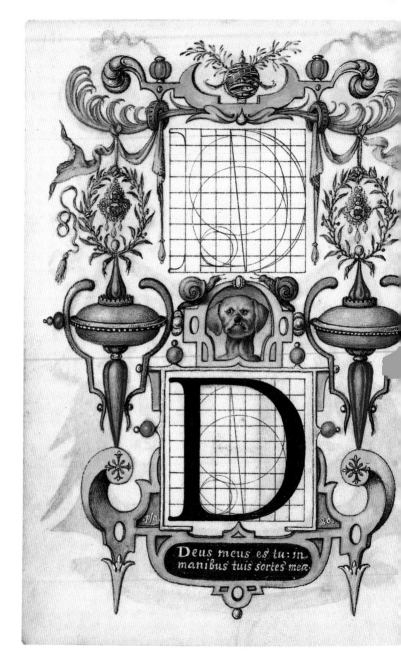

Deus meus es tu: in
manibus tuis sortes meæ.

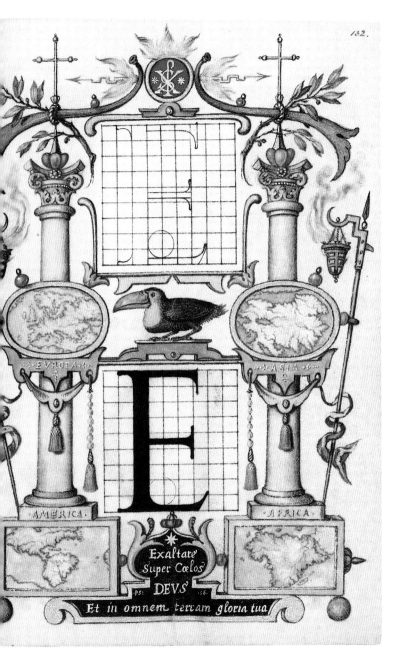

EVROPA · ASIA ·

AMERICA · AFRICA ·

Exaltare
Super Cœlos
DEVS
·ps· ·56·

Et in omnem terram gloria tua

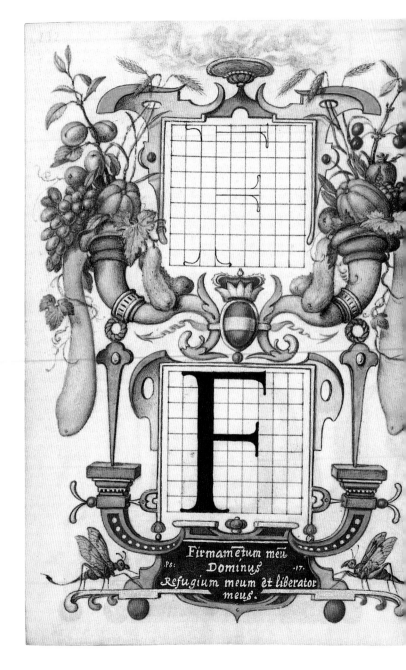

Firmamẽtum meũ
Dominus
Refugium meum et liberator
meus.

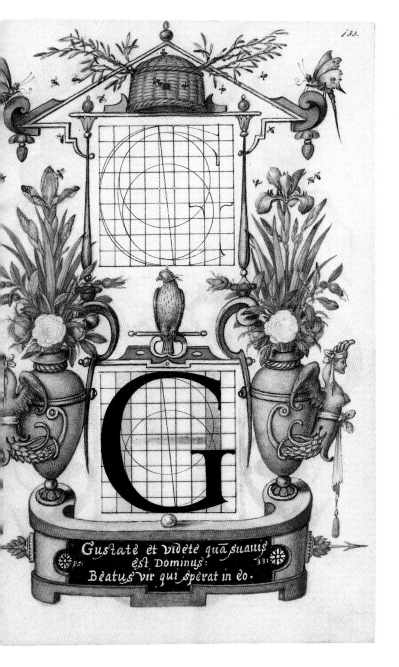

Gustate et videte quā suauis
est Dominus:
Beatus vir qui sperat in eo.

ps. 33.

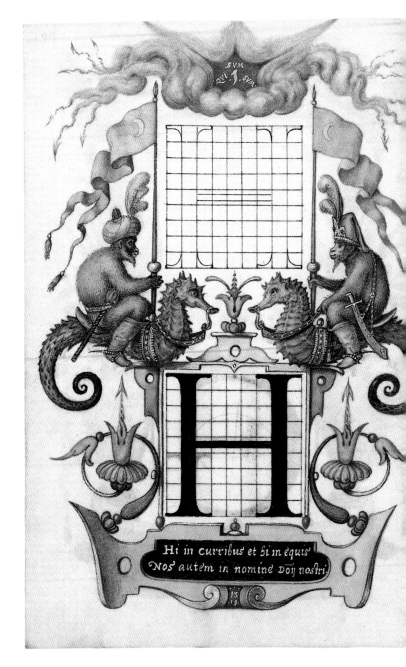

SVM
QVI J. SVM

Hi in curribus et hi in equis
Nos autem in nomine Doi nostri.

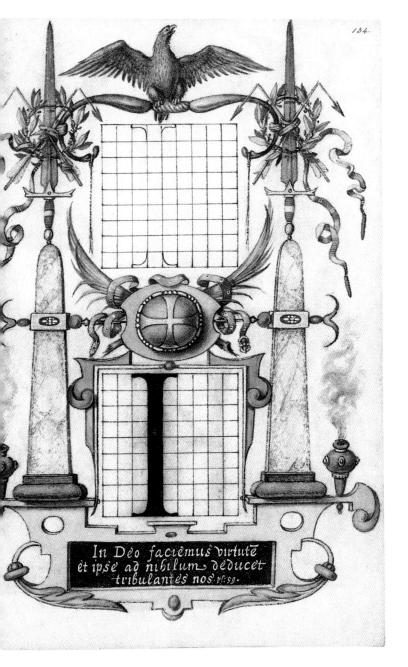

In Deo faciemus virtutē
et ipse ad nihilum deducet
tribulantes nos. ps: 59.

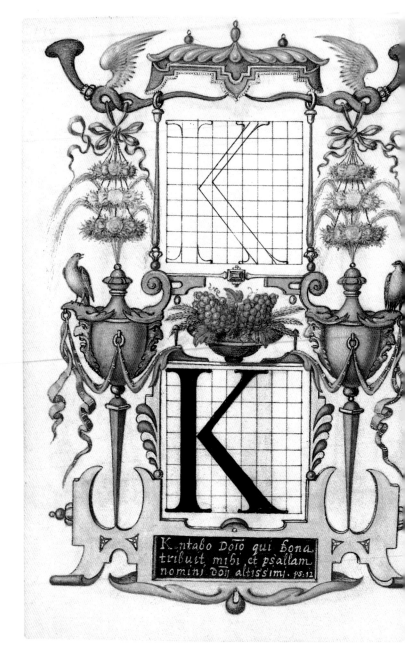

Kantabo Dō̄ qui bona
tribuit mihi, et psallam
nomini Dōī altiss̄imi. 15.12

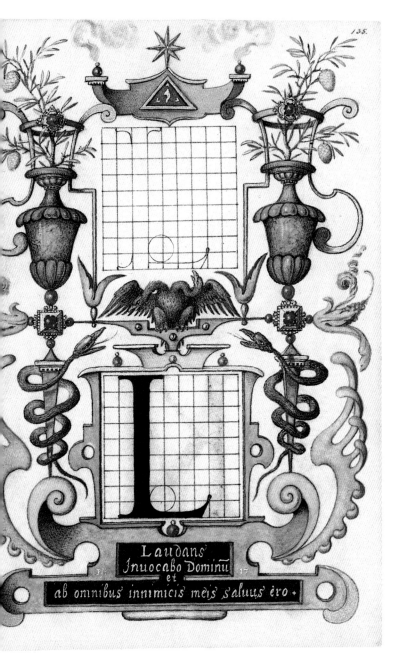

Laudans
Inuocabo Dominū
et
ab omnibus inimicis meis saluus ero.

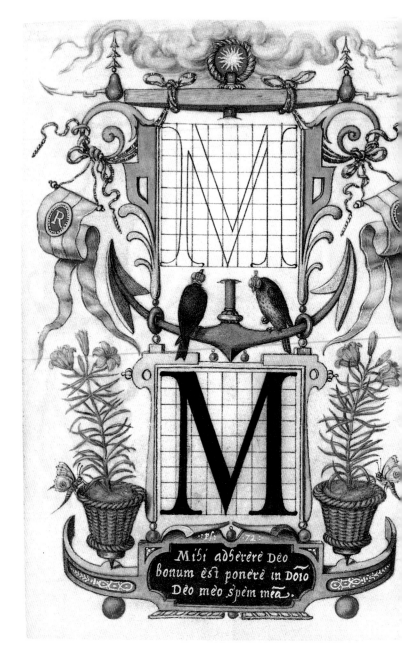

Ps. 72.

Mihi adhærere Deo
bonum est ponere in Dño
Deo meo spem meã.

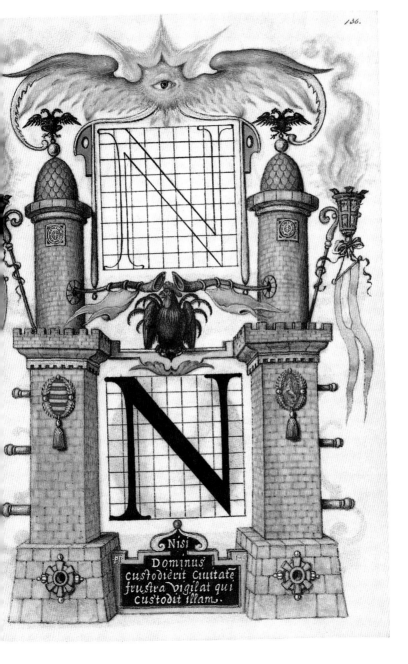

Nisi Dominus custodierit ciuitatē frustra vigilat qui custodit illam.

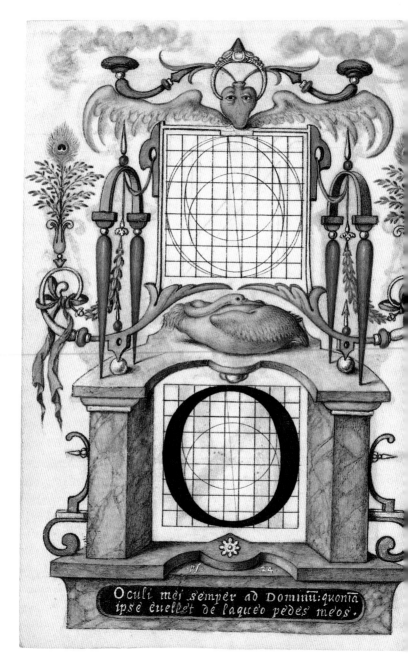

Oculi mei semper ad Dominū: quoniā
ipse euellet de laqueo pedes meos.

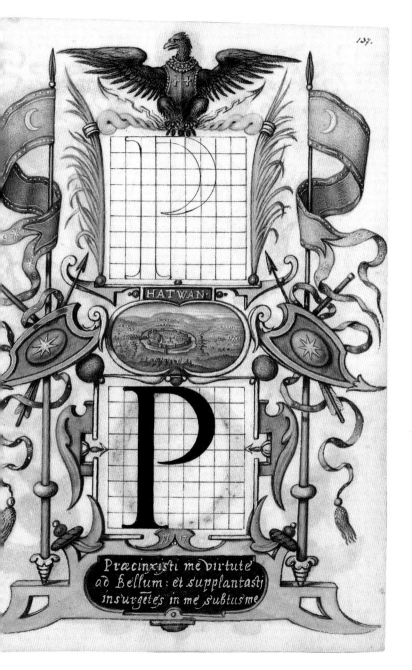

137.

HATWAN

Præcinxisti me virtute
ad Bellum: et supplantasti
insurgetes in me subtus me

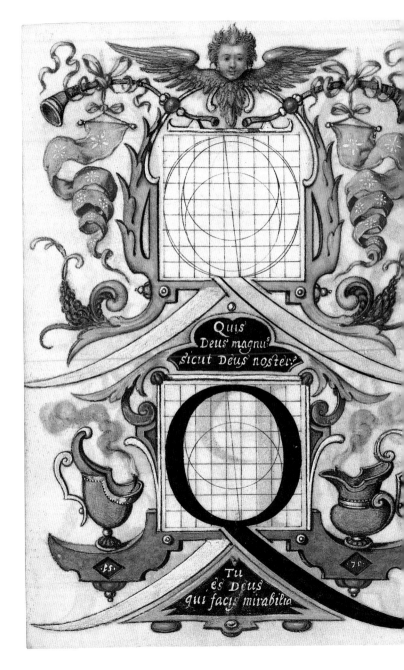

QUIS
DEUS MAGNUS
SICUT DEUS NOSTER?

TU
ES DEUS
QUI FACIS MIRABILIA

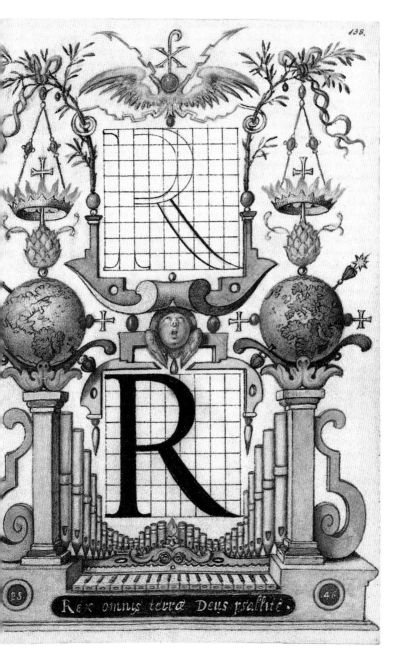

Rex omnis terræ Deus psallite.

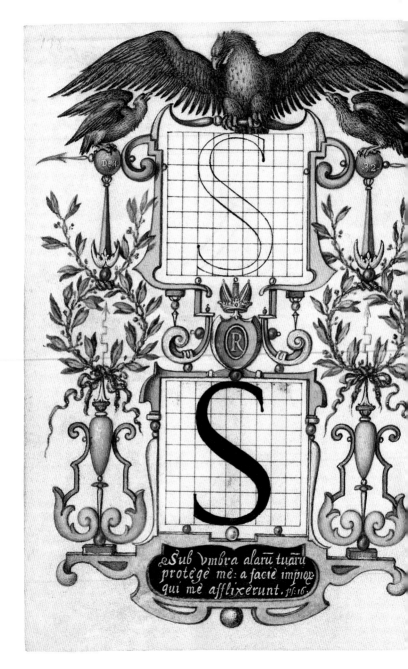

Sub vmbra alarū tuarū
protege me: a facie impior
qui me afflixerunt. *ps: 16.*

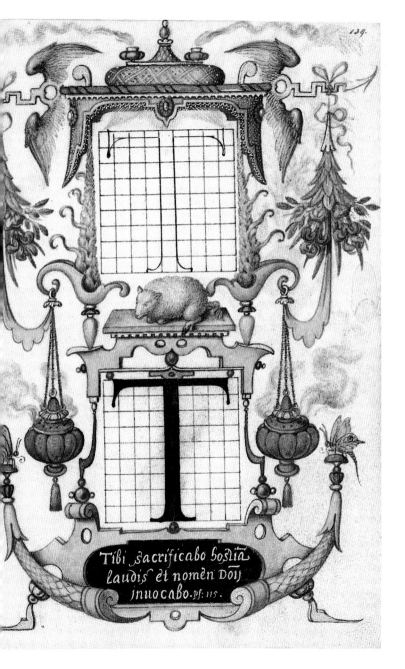

Tibi sacrificabo hostiã
laudis et nomen Dõij
inuocabo. Ps. 115.

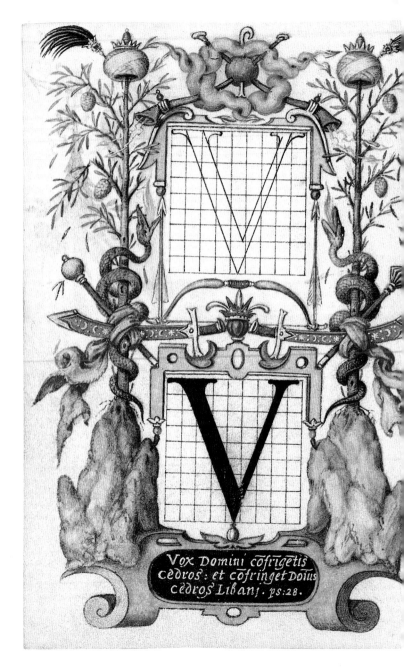

Vox Domini cofrigetis
cedros: et cofringet Doīus
cedros Libani. ps:28.

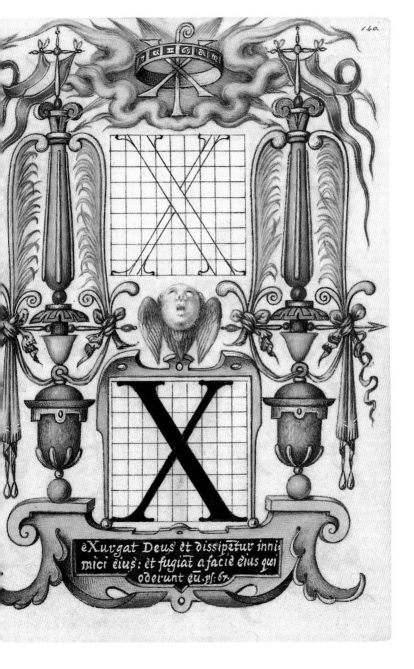

eXurgat Deus et dissipetur inni-
mici eius: et fugiat a facie eius qui
oderunt eu. ps: 67.

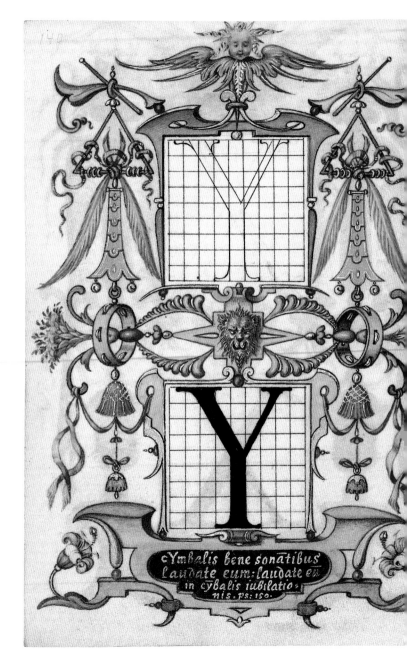

cYmbalis bene sonātibus
laudate eum: laudate eū
in cymbalis iubilatio-
nis. ps: 150.

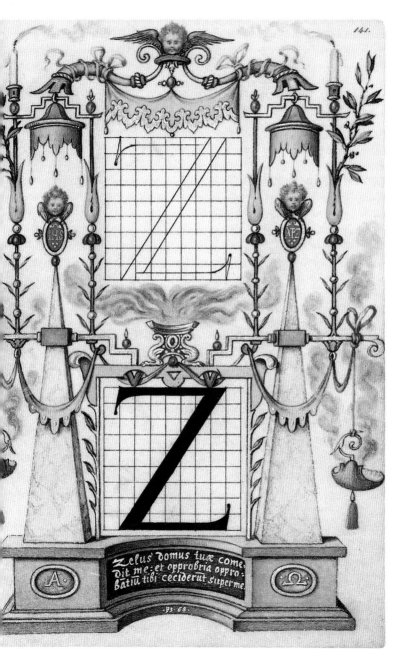

Zelus domus tuæ come
dit me: et opprobria oppro
bātiu tibi ceciderut super me.

·Ps· 68·

THE
GOTHIC MINUSCULE
ALPHABET

*H*oefnagel's Gothic lower-case alphabet differs
markedly from his classically inspired Roman capital alphabet.
Gothic letter forms were regarded as barbaric and uncultivated by the
Italian humanists of the Renaissance, and the artist decorated his
alphabet accordingly. A grotesque mask usually occupies the
centre of the folio, from which point intricate forms emanate in all
directions. This dynamic construction contrasts with the classical
serenity of the imagery surrounding the Roman capitals.
The relationships between the individual elements in any single
illumination are loose in terms of both form and content.
The depictions are not usually naturalistic, the notable exceptions
being the dogs, monkeys and birds. The masks are
either based on or inspired by a popular series of masks
engraved on copper by Frans Huys after
works by Cornelis Floris.

Captions to the plates on p. 49 ff.

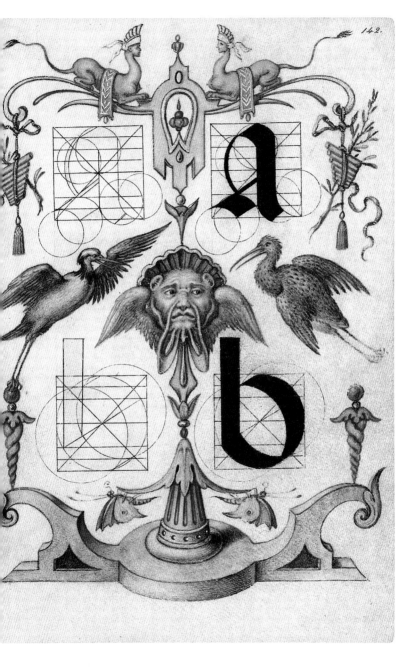

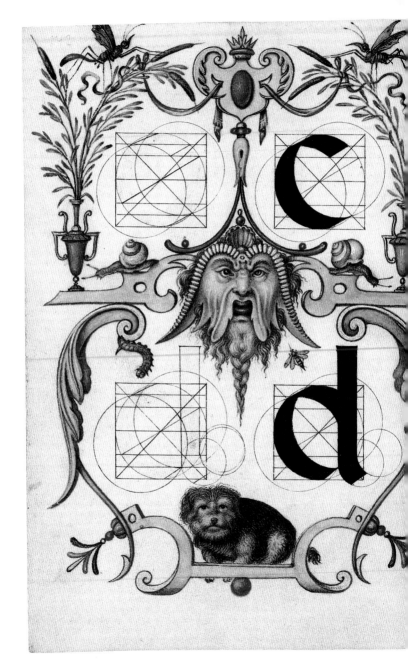

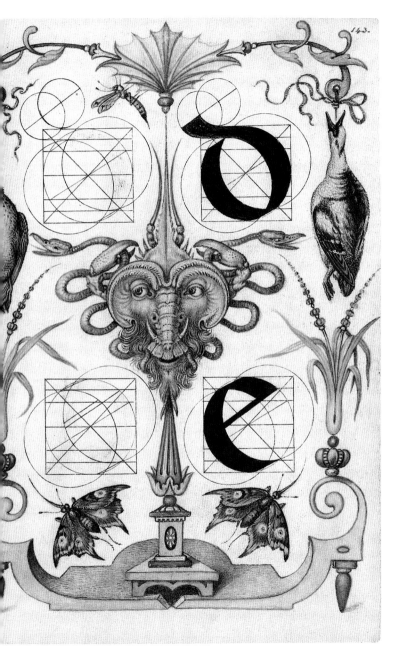

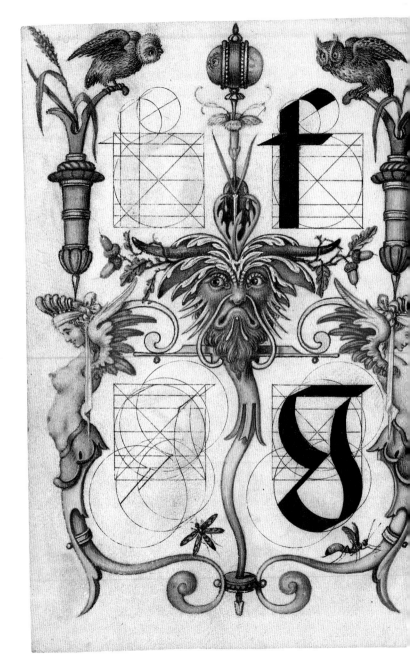

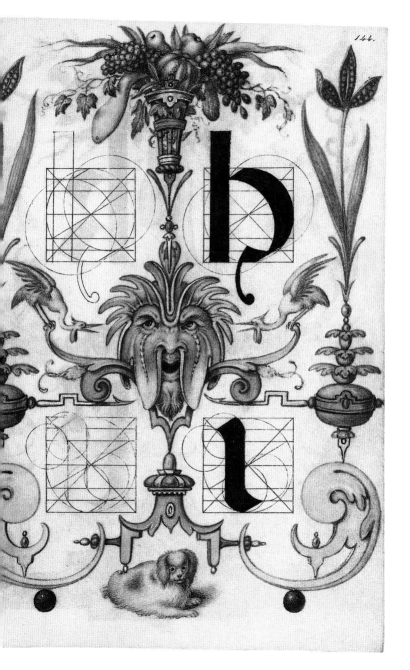

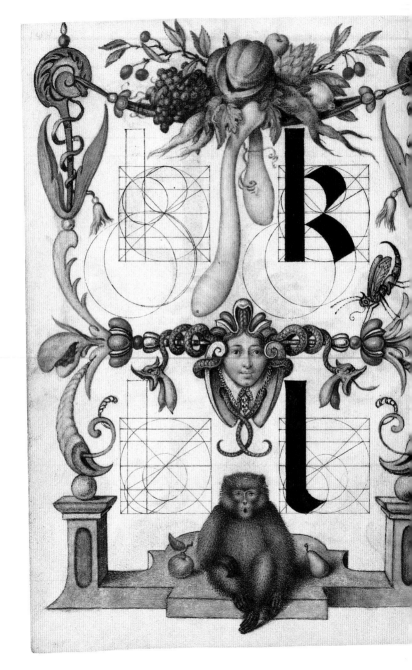

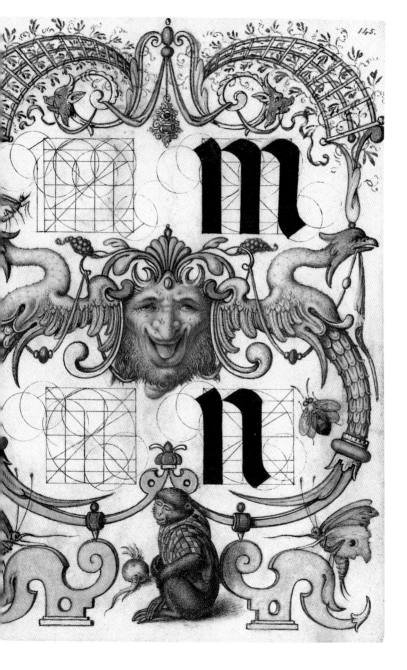

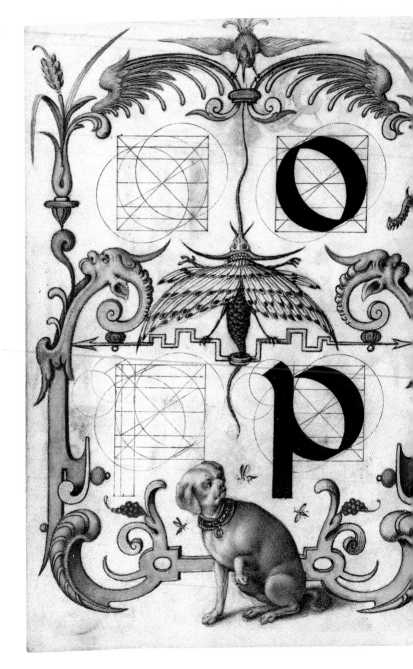

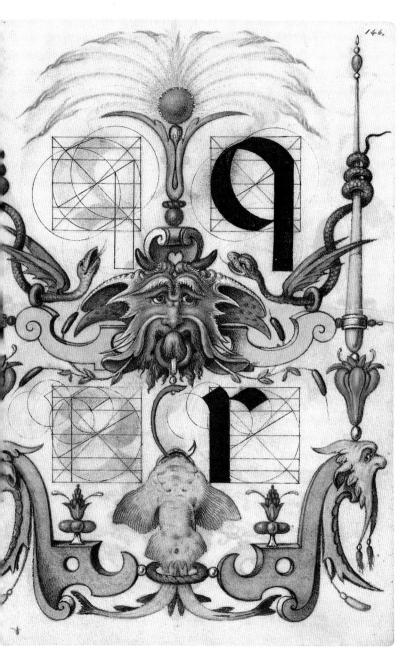

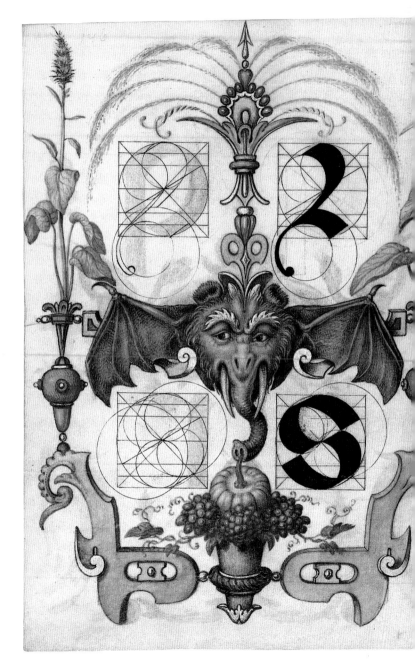

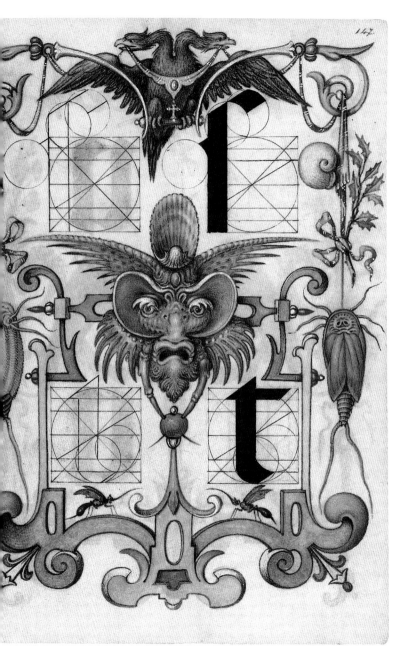

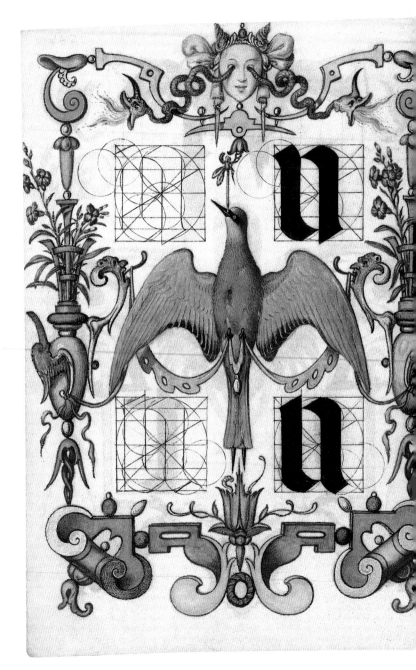

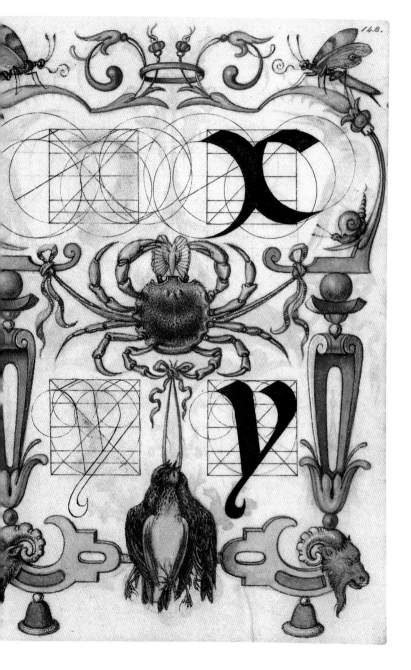

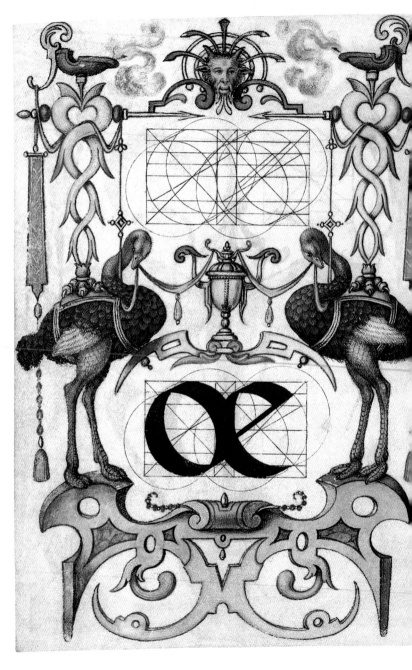

Notes on the Illustrations

Biblical quotations in Latin are from Robertus Weber, ed., *Biblia sacra iuxta vulgatam versionem*, vol. 1: Genesis–Psalmi (Stuttgart, 1983). English translations are from *The Holy Bible: Douay Rheims Version* (Baltimore, 1899).

ffl *(Frontispiece) Folio* 151v

This is the final folio of the codex and it is used to honor the patron of the illuminations. This is also the only place in the manuscript where Joris Hoefnagel sheds his anonymity. The top half of the page is dedicated to Emperor Rudolf II. The double-headed eagle wears a breastplate with his initial. The two heads jointly hold a laurel wreath, a symbol of glory, in their beaks. Their talons clasp lightning flashes, signifying power. The eagle's heads are protected by a double canopy. The imperial crown is shown in the middle of the canopy above the laurel wreath. Laurel branches and palm fronds, symbols of glory and triumph, honor the emperor.

The artist used the lower half of the page as if it were a colophon. At the bottom, he painted his own emblem: a horseshoe and nail (Hoef-nagel), the nail entwined with a G (Georgius). In addition, he furnished the picture with one of his mottoes, "In defectu valor" (Value lies in imperfection). The year 1596 is given as the year the illumination was completed (*Absolutum Anno 1596*). A ribbon, threaded through the horseshoe, is connected at the left to various brushes, drawing pens, and a right angle; at the right are a drawing pencil and compass. Bowls and shells for mixing pigments as well as other utensils essential to the miniaturist are also represented. Emblematic of Hoefnagel's dual talents as humanist and artist are the twin depictions of owls, the bird of Minerva, wearing her helmet and holding the caduceus of Mercury in their claws. A paintbrush has been substituted for the staff of each caduceus.

A Folio 130. Rev. 1.8: *Ego alpha et omega, principium et finis* (1.8: I am the A and the O, the beginning and the end).

The first written symbol, the letter *A*, pays homage to God, the ruler of heaven and earth, " the beginning and the end," to whom the Revelation of Saint John the Divine is consecrated. The biblical verse, accompanied by the tetragram of God's name, is quoted within a stylized omega in the middle of the page and in a cartouche in the bottom margin. With this verse, the first letter of the Greek alphabet simultaneously refers to the last one. The blue medallion containing the tetragram of his name occupies the center of the folio. It connects the constructional drawing of the letter *A* with its executed version and is surrounded by the omega, which generates flashes of lightning and thunderheads as symbols of God's might.

In the upper margin, a cherub is surrounded by a laurel wreath – a sign of God's fame – and flanked by incense burners. This angel praises the Lord along with the cherubim in the side margins. At both left and right, eternal lights burn in praise of God, as do candles entwined by olive branches, which symbolize his peace. Four demonic winged insects (the two antennae on the abdomens of the two upper ones indicate that they are Ephemerae, whose life span is a single day) are attracted by the flames.

B Folio 130v. Pss 102.1: *Benedic anima mea Domino et omnia viscera mea nomini sancto eius* (102.1: Bless the Lord, O my soul: and let all that is within me bless his holy name).

Just as the illumination of the first page of the constructed alphabet honors God as ruler of the universe, Hoefnagel dedicated the illumination of the second page to the worldly ruler, the emperor, dominating the earthly realm through God's grace and under his aegis. While the biblical verse, which begins with the letter *B*, praises the celestial Lord, the representation transfers the praise of God to the worldly ruler, Emperor Rudolf II, the illuminator's patron.

Like the medallion with the tetragram on folio 130, a medallion with the letter *R* (Rudolf) under the imperial crown occurs at the center of this

illumination. In the top margin are symbols of the emperor's sovereignty, the orb and the sword of state; the sword is crossed with a palm frond, a symbol of victory. To the left and right of these imperial insignia are the crowned Hungarian and Bohemian coats of arms, representing the royal dignity of Rudolf, king of both Hungary and Bohemia. In each side margin, an eagle, symbol of the emperor, holds in its beak a swag tied to one coat of arms and to Rudolf's medallion. As on folio 130, flashes of lightning and thunderbolts emanating from colorful wings indicate the emperor's mighty sovereignty. Likewise, the pair of incense burners that lure insects to their death symbolizes his capacity to destroy his enemies.

C Folio 131. Pss 103.33: *Cantabo Domino in vita mea, psallam Deo meo quamdiu sum* (103.33: I will sing to the Lord as long as I live; I will sing praise to my God while I still have my being).

The letter C initiates a series of illuminations based on the theme of praising God. The scrollwork that frames the finished, as opposed to the constructed, letter forms a lectern that supports a small songbook partly hidden by a stylized lyre. The activities of singing (*cantabo*) and its instrumental accompaniment (*psallam*; literally, to play the psaltery) are referred to by almost every other motif in the illumination. Thus sing the cherub with half-open mouth and the two thrushes (*Turdus philomelos*) with open beaks, all with their heads turned toward heaven.

Hanging down on both sides of this folio are woodwind and string instruments – tied together with tasseled ribbons – which yield soft tones that blend harmoniously with the human voice. At the left are a spelter, a shawm, and a cister; at the right, a lute replaces the latter instrument. Below them, on both sides of the executed letter, bright parrots alight on the marbled scrollwork. Within this holy concert, only the two insects in the bottom corners of the scrollwork frame are out of tune.

D Folio 131v. Pss 30.15–16: *Deus meus es tu. In manu tua tempora mea* (30.15–16: Thou art my God. My lots are in Thy hands).

This verse heralds the psalmist's devotion to and faith in his Creator. The astrolabe in the middle of the top margin, a symbol of eternity, is pierced by two olive branches, symbols of peace; palm fronds, symbols of victory, unfold to the left and right. From each of the palm fronds hangs a laurel

wreath – a sign of fame – surrounding a gold medallion set with precious gems and pearls. In this context, such treasure stands for the Divinity. Just as the devout person praising the Lord is portrayed by the parrot on folio 131, the pious person is here represented in the middle of the page by the head of the dog, who accompanies his master faithfully through every situation in life. The dog symbolized fidelity in contemporary iconography.

E Folio 132. Pss 56.12: *Exaltare super caelos Deus in omni terra gloria tua* (56.12: Be thou exalted, O God, above the heavens: and Thy glory above all the earth).

In the top margin is an azure medallion with the Greek letters *X, P,* and *S* (the chi-rho-sigma monogram for *Christus*) surrounded by a frame. Lightning flashes and thunderheads emanate from the name of Christ as do horns, attached to laurel branches, signs of his glory. The empire of Christ, symbolized by the Latin cross, stretches across the entire world, as is evidenced by maps of Europe, Asia, the Americas, and Africa. The two columns at the left and right not only create a decorative framework but, together with the maps, bring to mind the so-called Pillars of Hercules, which Emperor Charles V used as his emblem, accompanied by the motto "Plus ultra" (Even farther). This motto proclaimed that his empire extended even beyond the Pillars of Hercules.

The toucan in the middle of the page probably does not have specific symbolic meaning but indicates, through its exotic appearance, the foreign peoples and lands that had been incorporated into the empire and converted to Christianity since the beginning of the sixteenth century.

F Folio 132v. Pss 17.3: *Dominus firmamentum meum et refugium meum et liberator meus* (17.3: The Lord is my firmament, my refuge, my deliverer).

Whereas the psalmist calls out to the heavenly Lord as his support and refuge, the illumination depicts the wealth and abundance resulting from the rule of God's earthly representative, thus referring to the alphabet's patron, Rudolf II. Rudolf here is considered as the originator of the contemporary golden age, not, however, in his capacity as Holy Roman Emperor but as the ruling archduke of the house of Austria. The lightning flashes representing his might and the abundant cornucopias are attached to the Austrian coat of arms in the middle of the page.

Pouring from the cornucopias are ripe fruits of the orchards and fields such as melons, grapes, peaches, cherries, a pomegranate, squash, and ears of corn.

The incense bowl in the middle of the top margin, probably burns here to honor the heavenly emperor. The two insects, whose comical forms fit so organically into the fantasy architecture of the grotesque ornament, are probably to be understood here in a general sense as beleaguering those who yearn for faith, peace, and abundance.

G *Folio 133. Pss 33.9: Gustate et videte quoniam bonus Dominus. Beatus vir qui sperat in eo* (33.9: O taste, and see, that the Lord is sweet. Blessed is the man that hopeth in him).

The invitation of the psalmist to taste the sweetness of the Lord is taken literally here: bees – i.e., pious creatures – swarm around luxuriant bouquets of roses and irises, exemplifying God's creation, and sip nectar from ripe blossoms. This nectar is transformed into the honey in the hive in the middle of the top margin. Out of the hive, which refers to the house of God and the community of all believers, grow olive branches, symbolizing peace. Devilish adversaries in the form of mothlike insects lie in wait for the bees (God's servants) outside the hive. In spite of their small size, the bouquets are composed of flowers based on studies from nature.

Irises and roses are early summer flowers that were closely associated with the Virgin Mary; it is possible that there is a deeper symbolic significance to the bees' sipping nectar from the flowers. In the second half of the sixteenth century, the image of the hive – which is probably used as a symbol here, as is indicated by the olive branches – often referred to the Roman Catholic church, due to the formal similarity to the papal tiara. The image was also used to parody the church, however.

The falcon patiently awaiting removal of its hood in order to regain its sight illustrates the second part of the biblical verse. In sixteenth-century emblematics, the hunting falcon embodied hope due to its confidence in its imminent release from darkness.

H *Folio 133v. Pss 19.8: Hii in curribus et hii in equis, nos autem nominis Domini Dei nostri recordabimur* (19.8: Some trust in chariots and some in horses; but we will call upon the name of the Lord our God).

This verse forms part of a prayer to be said in time of war, praising the power of the Lord and predicting the downfall of his enemies. The psalmist continues: "They have fallen and died, but we stand resurrected."

The psalmist's plea for protection from the enemies of Israel has been transformed in this illumination into a contemporary prayer for God's help in the battle against the enemies of the empire, especially the Turks, who posed an ongoing threat. In 1593, war broke out again. Like the battle waged by the children of Israel, the fight against the Turks was understood primarily as a religious war. The Muslim Ottomans are symbolized here by monkeys with spurred boots and feathered headgear. They ride into battle on sea horses and fly the Ottoman crescent-moon banner. Lightning flashes and thunderheads, symbols of power, are directed against the charging apes, enemies of the faith. The source of the former is a three-pointed star inscribed with the motto "Sum unus qui unus sum" (I am the triune union), a sign of the Trinity.

I Folio 134. Pss 59.14: *In Deo faciemus virtutem et ipse ad nihilum deducet tribulantes nos* (59.14: Through God we shall do mightily: and he shall bring to nothing them that afflict us).

Here, too, the battle of the Israelites against their enemies serves as a typological counterpart of the Holy Roman Emperor's war against the Turks. This struggle was waged under the protection and shield of God. The central oblong shield of faith decorated with the sign of the cross was to be worn in battle; hence the belt or straps. Behind the shield are two palm fronds signifying certain victory. Hoefnagel's pictorial language here reflects the iconography of the militant Ignatius Loyola and the Jesuit order, which portrayed life as military service for the Catholic church.

An obelisk at each side of the composition supports a sword whose hilt is decorated with the colors of the house of Austria, red and white. Representing justice, these weapons simultaneously refer to the imperial insignia of the sword of state, just as they do on folio 130v. Their decoration with laurel wreaths signifies the emperor's fame. The two broken arrows crossed behind the swords are meant as trophies of his victory, for, according to the second part of the biblical verse, enemies are defeated with the help of God. The one-headed eagle enthroned between the two swords refers to Rudolf II.

K *Folio* 134v. Pss 12.6: *Cantabo Domino qui bona tribuit mihi et psallam nomini Domini altissimi* (12.6: I will sing to the Lord, who giveth me good things: Yea I will sing to the name of the Lord the most high).

For the *K* missing in the classical Latin alphabet Hoefnagel substituted the homophonic *C*. The content of this verse is roughly equivalent to that on folio 131 for the letter *C*. The song of praise to God is sung on both folios by birds (*cantabo*), though here the instrumental music-making is expressed by two knotted, winged horns. The birds have alighted on urns decorated with grotesques, out of whose lids spring thin streams of water. The water refreshes three wreaths of roses in the colors of the house of Austria that hang down from the winged horns.

According to the psalmist, fresh, blooming flowers are among the gifts that God gives humanity. Other gifts (*bona*) are the fruits of the fields and trees – here, sheaves of wheat and grapes arranged in a shallow bowl in the middle of the page. The earthly gifts are themselves references to the bread (wheat) and wine (grapes) of the Eucharist. The fountainlike water refreshing the flowers alludes to the sacrament of baptism.

L *Folio* 135. Pss 17.4: *Laudans invocabo Dominum et ab inimicis meis salvus ero* (17.4: Praising I will call upon the Lord: and I shall be saved from my enemies).

The upper part of this illumination glorifies the Divinity, symbolized by the equilateral triangle, a sign of the Trinity. As on folio 133v, the number one in the center refers to the triune union. Also the eight-pointed star, the incense burners, and the branches with pinecones signify the veneration of the eternal (star) and immortal (pine bough) God.

The second part of the verse is illustrated on the bottom half of the folio: helical snakes – i.e., hostile powers – hiss furiously with wide-open mouths at the double-headed eagle in the middle of the page. One of the eagle's heads looks down, toward one of the snakes, while the second head looks up, in adoration of God. The eagle thus connects the two parts of the verse referring to God on the one hand and humanity's enemies on the other.

Although there is neither monogram nor coat of arms alluding to Rudolf II, the entire illumination is nevertheless to be associated with him. One of his emblems was the double-headed eagle, which here turns

one head toward the sun – i.e., God – and the other toward the snakes that threaten it.

M Folio 135v. Pss 72.28: *Mihi autem adpropinquare Deo bonum est, posui in Domino Deo spem meam* (72.28: But it is good for me to adhere to my God, to put my hope in the Lord God).

Like all flowers that open their blooms toward the light, day-lilies symbolize creatures that turn toward God in adoration and confession. As such, they embody the first part of the biblical verse here. The well-known verse from Matthew, "Look at the lilies in the field, how they grow; they do not work, nor do they spin" (Matt. 6:28), was the origin of the lily's identification with the devout person who puts his or her life in God's hands with the greatest confidence.

The illuminations connected to the second part of the verse refer to hope fixed on God. The many-pointed star, God's symbol, generates lightning flashes and thunderheads as signs of his power and crowns an anchor that forms the basic framework for the illumination of the page as a whole. The anchor is a traditional symbol of hope. Here, it has been rendered in *trompe l'oeil* as if piercing the vellum behind the constructed *M*. On the anchor's arms sit two hooded falcons. As on folio 133, they embody the hope of the faithful for release from the darkness. The first-person voice of the biblical verse is associated with Rudolf II through the initial *R* in medallions on the red and white banners of the house of Austria. The flags are fastened to the scrollwork frame by colorful bands. This folio has been transformed by its illuminations into a personal confession of faith by the emperor.

N Folio 136. Pss 126.1: *Nisi Dominus custodierit civitatem frustra vigilat qui custodit eam* (126.1: Unless the Lord keep the city, he watcheth in vain that keepeth it).

Here, we see fortifications composed of square foundations of large stone blocks, with square towers surmounted by battlements. On these are round towers pierced by marksman's holes. The entire structure protects the universal *civitas* of the terrestrial ruler, the Holy Roman Empire, here symbolized by the double-headed eagles atop the two domes, the coats of arms of Hungary at the left and Bohemia at the right, and the banners in

the colors of the house of Austria that hang from the incense burners. The clock strikes midnight, the watchman sounds the horn. A cock – symbol of supreme vigilance – sits between the two towers with its wings spread. Defenses and vigilance would be in vain, however, were it not for God – the three-pointed star of the trinity – and his might (wings with flames) watching protectively over the empire, as is evidenced by the wide-open eye within the star.

O *Folio 136v. Pss 24.15: Oculi mei semper ad Dominum quia ipse educet de rete pedes meos* (24.15: My eyes are ever towards the Lord: for he shall pluck my feet out of the snare).

The illumination of this page is difficult to interpret. The eyes of the believer, who is the subject of the biblical verse, look toward God; the heart of the believer, with its wide-open eyes and wings signifying its heavenly orientation, refers to spiritual insight that turns the heart of the believer to God. The Divinity is honored by the presence of incense bowls in the top margin. The diamond in the ring above the heart might symbolize Christ, since he was as invulnerable as a pure diamond that could not be cut. The peacock feathers in the side margins, which elsewhere symbolize pride, are probably to be understood here as references to people of virtue. The "eyes" on these feathers recall the "oculi" of the biblical verse. Hoefnagel employed the peacock as a symbol of virtue in other instances.

The long-necked bird in the middle of the page, which seems to be curled up in sleep, is most likely a swan. Since the Latin word for swan, *olor*, begins with the letter O, this may be why Hoefnagel chose it as the symbol of evil. In its somnolent state, however, the bird is unable to threaten the vigilant faithful.

P *Folio 137. Pss 17.40: Accinxisti me fortitudine ad proelium, incurvabis resistentes mihi sub me* (17.40: And thou has girded me with strength into battle; and has subdued under me them that rose up against me).

The gratitude of the psalmist and his confidence that God would aid him in the battle against the enemies of Israel are transposed into the emperor's prayer of thanks to God for his help in securing victory over the Turks. The imperial eagle wears a cuirass, holds lightning flashes and

thunderheads in its talons as signs of its power, and is flanked by two palm fronds of victory. Standards with the Ottoman crescent moon and capture weapons (arrows, maces, and shields) are depicted as trophies in both margins. Imperial troops laid siege to the Hungarian city of Hatvan, in the district of Heves, fifty kilometers east-northeast of Budapest, on August 15, 1596. The fortifications had been taken on September 3, resulting in a bloodbath among the Muslim population. The view of Hatvan refers to this siege. This was one of the few victories the emperor won over the Turks during this period.

Q Folio 137v. Pss 76.14–15: *Quis deus magnus ut Deus? Tu es Deus faciens mirabilia* (76.14–15: Who is the great God like our God? Thou art the God that dost wonders).

The size of the constructed and completed Qs left Hoefnagel little space for illuminations. The biblical verse that praises God's power and wondrous deeds is given figural expression at the top by a cherub's head and two trumpets sounding his praise and at the bottom by two incense burners. The composition is built around the framework provided by the tails of the Qs, primary ones extending to the right and secondary ones – apparently added for the sake of symmetry – to the left. In this illumination, the scrollwork frame and objects attached to it are subordinated to the form of the letter.

R Folio 138. Pss 46.8: *Quia Rex universae terrae Deus canite crudite* (46.8: For God is the king of all the earth: sing ye wisely).

An organ with its pipes arrayed around the letter *R* illustrates the word *psallite*. Music is made in honor of God, king of the entire earth. As on folio 132 with the letter *E*, the earth is represented by terrestrial globes, here showing the Americas at the left and Europe, Africa, and Asia at the right. God is the ruler of the earth: the scepter drilled through the planet carries an eight-pointed star – his symbol. Two imperial orbs also flank each globe. God, the mighty king (*Rex* of the biblical verse, alluded to by the flaming crowns encircling crosses) is the ruler of eternity (pine-cones). In his realm, peace rules (olive branches). Above, the power of Christ is symbolized by the Greek letters *X* and *P*, the wings of angels, and lightning flashes. A cherub in the middle of the page sings God's praises.

S *Folio 138v. Pss 16.8–9: In umbra alarum tuarum protege me, a facie impiorum vastantium me* (16.8–9: Protect me under the shadow of thy wings. From the face of the wicked who have afflicted me).

The emperor, represented by the eagle, turns with concern toward his subjects (symbolized by smaller birds), shielding them with his power (his wings). Inspired by the biblical text and iconographically reminiscent of the typology of the Virgin of Mercy who shelters believers under her cloak, the imperial eagle here represents the solace and refuge of the emperor's subjects. Entwined laurel branches glorify his fame; vertical lightning flashes proclaim his power. A medallion with the initial *R* under the crown in the middle of the page glorifies Emperor Rudolf II as the protector of his subjects.

T *Folio 139. Pss 115.17: Tibi immolabo hostiam laudis et in nomine Domini invocabo* (115.17: I will sacrifice to thee the sacrifice of praise, and I will call upon the name of the Lord).

On an altar in the middle of the page, the paschal lamb patiently awaits its sacrificial death. Incense rises from burners at the left and right. In the top margin, the richly decorated canopy shielding the lamb resembles the tabernacle containing the Host. Incense bowls appear at the very top. Wings (divinity), lightning flashes (power), and hanging bouquets of roses, iris, and wheat are depicted in the side margins. The Easter lamb symbolizes the Eucharist, representing the Host through which the believer participates in humanity's salvation, realized by Christ's sacrificial death as the Lamb of God.

V *Folio 139v. Pss 28.5: Vox Domini confringentis cedros et confringet Dominus cedros Libani* (29.5: The voice of the Lord destroys the cedars; the Lord destroys the cedars in Lebanon).

The entire text of the psalm honors the voice of the Lord. Christ's monogram *XP* in the middle of the top margin forms the focus of this representation. The *X* is composed of two crossed horns emitting lightning flashes, a reference to the seventh verse of this psalm in which the Lord's voice spits flames; thunderbolts surround Christ's monogram. As elsewhere, they signify the power of God. According to the psalmist,

the Lord's voice forces cedar branches to bend and break and their evergreen needles to drop. The feathered turbans crowning the trees mark these cedars as symbols of the Ottoman empire. Trophies hanging on each of the tree trunks consist of Turkish scimiters and maces. Fire-spitting snakes (i.e., enemies of the Christian empire) coil around the trees but are repelled by God's power.

X *Folio 140. Pss 67.2: Exsurgat Deus et dissipentur inimici eius et fugiant qui oderunt eum a facie eius* (67.2: Let God arise, and let his enemies be scattered: and let them that hate him flee from before his face).

In order to incorporate the *X* into his abecedarium, Hoefnagel used the second letter of a biblical verse. The letter's balanced structure led him to create a composition bound by strict symmetry, which gives the page as a whole a serene and sacred aura. The Roman letter *X* corresponds in form to the Greek letter *X* (chi). The page is thus illuminated with a symbolic representation of victory (four palms) in the name of Christ (in its form as the monogram *XP*), which is surrounded by lightning flashes and thunderheads and encircled by the signs of the zodiac, symbols of the universe. Here, too, victory over God's opponents is portrayed as the victory in God's name of the house of Austria (the red and white banners) over the Turks.

Y *Folio 140v. Pss 150.5: Laudate eum in cymbalis sonantibus, laudate eum in cymbalis tinnientibus* (150.5: Praise him on high sounding cymbals: praise him on cymbals of joy).

Just as with *X*, the letter *Y* appears as the second letter of a biblical verse. The illuminations here are more playful and less symbolically weighted, however. Suspended ethereally from the grotesque ornaments are different musical instruments, such as triangles and sticks, sleigh bells, tambourines, and tiny bells suspended from tassels. Their chimes and tinkles comprise the bright tones of which the biblical verse speaks. The decorative character of the ensemble is further enhanced by the lion's head in the middle of the page, which was taken from the repertoire of grotesques by Cornelis Floris.

Z *Folio 141. Pss 68.10: Quia zelus domus tuae comedit me e obprobrium exprobrantium tibi cecidit super me* (68.10: For the zeal of thy house hath eaten me up: and the reproaches of them that reproach thee have fallen upon me).

For the interpretation of the letter *Z*, Hoefnagel chose a verse from Psalms that is referred to several times in the New Testament. The psalmist's own annihilation, of which he speaks here, was thought to prefigure the sufferings of Christ. Hoefnagel's illumination of the biblical verse conforms to this typology. The two oval medallions with the name of Jesus Christ, *IHS XPS*, rest atop two obelisks, symbols of imperturbability. Laurel branches, trumpets, and cherubs beneath canopies proclaim God's fame. On an altar in the middle of the page, a fire burns, ignited by love for God.

The alphabetical cycle of Roman capital letters ends with *Z*. On this last page, the alpha and omega from folio 130, the first page of the constructed alphabet, occur again, at the feet of the obelisks bearing Christ's name.

THE GOTHIC MINUSCULE ALPHABET

a,b *Folio 142.* Like all the folios of the Gothic lower-case alphabet, this page is not illuminated with balanced classical motifs but with dynamic, playful imagery. The distorted face in the middle of the page is based on one of the series of grotesque masks engraved by Huys after drawings by Floris. The bizarre face was realistically rendered with great detail and plasticity. It is being attacked by two long-legged birds with slightly opened beaks one of whom is in midflight. Butterflies cling to the ornamental foliage in the bottom margin. The top edge of the page bears symmetrical pseudoclassical motifs: at each side lies a sphinxlike figure, hanging below which is a set of pan-pipes bound to an olive branch.

c,d *Folio 142v.* A mask based on the Huys/Floris series appears in the middle of this page. At the top, long-legged, winged insects land on stylized, thickly foliated cattails in small vases resting on scrollwork "shelves." Snails attempting to descend the steps of the scrollwork frame again demonstrate Hoefnagel's capacity to capture minute natural details. A realistically executed puppy, who looks out at the viewer with an expression of loyalty and devotion, crouches in the bottom border,

entrapped, as it were, by scrollwork and guarded by the mask. The playful interaction between the tactile, sensuous representations of natural forms and the flattened, stylized ornaments enhances the charm and wit of the design. The insect wing at the upper left has been clipped by the top edge of the page, suggesting that it, as well as the rest of the constructed alphabet, was severely cut down during binding.

d,e *Folio* 143. Perhaps the form of the Gothic letter *d*, with its closed curve and necklike ascender, inspired Hoefnagel to illuminate this folio with two dead ducks hanging by their bills. This motif, which was common in Flemish genre painting of the second half of the sixteenth century, became a subject in its own right in later still life painting. The middle of this page features a distorted face based on the Huys/Floris series. It is made out of parts of sea creatures, including a lobster tail and claws. The monster face fends off two hissing snakes. Below, two butterflies take to the air, lending a sense of weightlessness to the page's decorative scheme.

f,g *Folio* 143v. Hoefnagel was inspired here almost exclusively by the forms of the letters. Beaked vases extend to the right and left of the letter *f*, echoing its form vertically and horizontally. Owls sitting on the vases gaze into a double mirror in the middle of the top border. The owl regarding its own reflection was a common symbol of self-knowledge (in Greek, *gnoti seauton*). Here, however, the motif has no direct connection to the rest of the illumination, unless the letter *g* is implicitly linked with the word *gnoti*. The wild-man mask, again based on the Huys/Floris series, has hornlike oak branches growing out of its leafy hair and rests on an S-curve horn that follows the curved descender of the *g*. The naked bodies of the two caryatids at the left and right echo this movement.

h,i *Folio* 144. The brimming fruit basket at the top of the page (a grotesque motif Hoefnagel often used in an augmented form, treating it as a colorful and pungent still life) is balanced on a mask from the Huys/Floris series that is being attacked by two birds. Counterbalancing the horrific face is a woolly-furred puppy lying at the bottom border. The canopy above him indicates that this canine might have symbolic significance since the dog embodies pure Christian faith. Imaginary tall, seed-bearing plants fill the side borders.

k,l *Folio* 144v. Filling the middle of the page is the head of a young Medusa above a type of collar fashionable in Hoefnagel's time; her hair consists of hissing snakes. In the top margin, a bunch of plump, ripe fruit and tubers is displayed. The roguish monkey in the bottom margin has plucked an apple and a pear. Monkeys eating fruit are common as symbols of the sense of taste but also have a purely ornamental function in grotesque decoration.

m,n *Folio* 145. The upper bodies of two birds with scaly tails are hooked to either side of a coarse, fleshy caricature that forms the focal point of this composition. Their bodies echo the curves of the letters *m* and *n*. In the top margin, curving grotesques are intertwined with two arching trellises overgrown with foliage. Between the trellises hangs a massive jewel. Below it sits a monkey wearing a plaid jacket and about to eat a turnip. Two monstrous moths extend their proboscises toward the animal in order to sense what it is.

o,p *Folio* 145v. In place of a distorted face or mask, a fantastic insect with a scaly body and outspread, feathered wings occupies the middle of this page. Its demonic character is accentuated by the double lightning flashes on which it perches. Its tongue or stinger extends to the top margin, where a bird with spread legs waits to peck at the end of it. Plant and animal ornaments frame the letter forms, including two gargoyles with curling tongues. Below, a dog attempts to ward off swarming insects. It is distinguished from the other dogs depicted in the manuscript by its valuable collar, indicating that the animal might actually have belonged to the emperor.

q,r *Folio* 146. The double-tailed fish hanging on the hook at the bottom of this folio might be intentionally reminiscent of a stylized roach, whose name begins in German (as in English) with the letter *R* – just as the swan, *olor*, in Latin, was chosen to illuminate the letter O on folio 136v. Significantly, the hook from which the fish hangs is connected to a Neptune-like mask in the middle of the page reminiscent of one in the Huys/Floris series. A ball of fire above the mask emits a fan of flames. The mask itself is besieged by two snakes with dragons' wings. Bizarre scrollwork with gargoyle terminals fills the bottom margin.

r,s *Folio* 146v. A mask with the trunk and tusks of an elephant and bat's wings for ears dominates this illustration. The trunk reaches down to a basket containing a squash lying among grapes in the bottom margin. A fountain with ten streams of water cascades down on realistically depicted but imaginary plants decorating the side margins.

s,t *Folio* 147. On both sides of a central grotesque face topped by a cockleshell, exotic shellfish hang from scrollwork. At the top reigns the double-headed imperial eagle. With its heads facing left and right, it guards against the onslaught of potential enemies.

u,v *Folio* 147v. A woman's face, her hair twisted into two horns reminiscent of the fantastic Burgundian hairstyles of the fifteenth century and her eyesockets exuding fire-breathing, horned snakes, symbolizes vanity. The dead bird hanging by its beak in the middle of the page as well as the dianthus in the scrollwork vases can also be associated with mortality (*vanitas*). The colorful bird with its shimmering blue belly and blue-bordered wings is probably a stylized bee-eater (*Merops apiaster*). The drawing recalls Dürer's watercolor of the wing of a blue roller (*Coracias garrulus*), one of the other masterpieces in Rudolf's art collections.

x,y *Folio* 148. The form of the letter *x*, with its four rounded arms, led the artist to depict the crab with many legs and appendages that decorates the middle of this page. A cluster of dead partridges, a motif dating back to antiquity, hangs from the crab's legs. Insects and rams' heads decorate the scrollwork in the four corners of the page, and a lone snail occupies the middle of the right margin.

œ *Folio* 149v. To the left and right of an urn, two ostriches stand on a scrollwork base. Their elliptical bodies echo the ovals of the letters and the scrollwork that appears above and below them. The motifs in the scrollwork at the top, the stylized tendrils, the incense burners, a satyr's mask, and the ornamental bands – all of which belong to the grotesque repertoire – have been loosely but deftly assembled. All are balanced on saddles tied to the ostriches' backs.